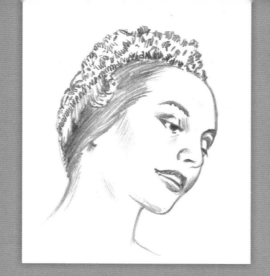

PEOPLE

with William F. Powell

From the subtleties of emotion conveyed by facial expressions to the limitless variety of shapes the human form can take, people are some of the most interesting subjects to draw. And knowing how to capture a human likeness is not only interesting and fun, it also gives you the confidence to explore a wider variety of subjects and compositions. This book presents the basic principles of drawing a variety of people, with lessons on facial features, perspective, and composition. You'll also learn how to render figures in action, the differences between adult and child proportions, and simple shading techniques that will bring a sense of realism to all your drawings of people.

—William F. Powell

CONTENTS

TOOLS & MATERIALS

Graphite pencil artwork requires few supplies, and fortunately they are fairly inexpensive. Choose professional pencils and paper, rather than student-grade materials; they will last longer and ensure a higher-quality presentation.

Pencils

Pencils are labeled based on their lead texture. Hard leads (H) are light in value and great for fine, detailed work, but they are more difficult to erase. Soft leads (B) are darker and wonderful for blending and shading, but they smudge easily. Medium leads, such as HB and F, are somewhere in the middle. Select a range of pencils between HB and 6B for variety. You can purchase wood-encased pencils or mechanical pencils with lead refills.

Wooden Pencil The most common type of pencil is wood-encased graphite. These thin rods—most often round or hexagonal when cut crosswise—are inexpensive, easy to control and sharpen, and readily available to artists.

Flat Carpenter's Pencil Some artists prefer using a flat carpenter's pencil, which has a rectangular body and lead. The thick lead allows you to easily customize its shape to create both thick and thin lines.

Carpenter's Pencil

Mechanical Pencil Mechanical pencils are plastic or metal barrels that hold individual leads. Some artists prefer the consistent feel of mechanical pencils to that of wooden pencils; the weight and length do not change over time, unlike wooden pencils that wear down with use.

Mechanical Pencil

Woodless Graphite Pencil These tools are shaped like wooden pencils but are made up entirely of graphite lead. The large cone of graphite allows artists to use either the broad side for shading large areas or the tip for finer strokes and details.

Woodless Pencil

Graphite Stick Available in a full range of hardnesses, these long, rectangular bars of graphite are great tools for sketching (using the end) and blocking in large areas of tone (using the broad side).

Graphite Stick

Paper

Paper has a tooth, or texture, that holds graphite. Papers with more tooth have a rougher texture and hold more graphite, which allows you to create darker values. Smoother paper has less tooth and holds less graphite, but it allows you to create much finer detail. Plan ahead when beginning a new piece, and select paper that lends itself to the textures in your drawing subject.

Blending Tools

There are several tools you can use to blend graphite for a smooth look. The most popular blenders are blending stumps, tortillons, and chamois cloths. Never use your finger to blend—it can leave oils on your paper, which will show after applying graphite.

Stumps Stumps are tightly rolled paper with points on both ends. They come in various sizes and are used to blend large and small areas of graphite, depending on the size of the stump. You can also use stumps dipped in graphite shavings for drawing or shading.

Tortillons Tortillons are rolled more loosely than a stump. They are hollow and have one pointed end. Tortillons also come in various sizes and can be used to blend smaller areas of graphite.

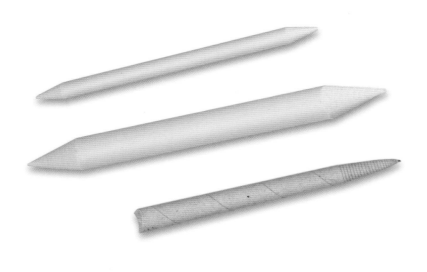

Facial Tissue Wrap tissue around your finger or roll it into a point to blend when drawing very smooth surfaces. Make sure you use plain facial tissue, without added moisturizer.

Chamois Chamois are great for blending areas into a soft tone. These cloths can be used for large areas or folded into a point for smaller areas. When the chamois becomes embedded with graphite, simply throw it into the washer or wash by hand. Keep one with graphite on it to create large areas of light shading. To create darker areas of shading, add graphite shavings to the chamois.

Erasers

Erasers serve two purposes: to eliminate unwanted graphite and to "draw" within existing graphite. There are many different types of erasers available.

Kneaded This versatile eraser can be molded into a fine point, a knife-edge, or a larger flat or rounded surface. It removes graphite gently from the paper but not as well as vinyl or plastic erasers.

Block Eraser A plastic block eraser is fairly soft, removes graphite well, and is very easy on your paper. Use it primarily for erasing large areas, but it also works quite well for doing a final cleanup of a finished drawing.

Stick Eraser Also called "pencil erasers," these handy tools hold a cylindrical eraser inside. You can use them to erase areas where a larger eraser will not work. Using a utility razor blade, you can trim the tip at an angle or cut a fine point to create thin white lines in graphite. It's like drawing with your eraser!

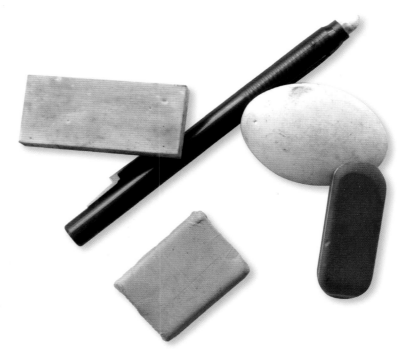

SHADING TECHNIQUES

The key to transforming flat, simple shapes into convincing, lifelike forms is to employ a variety of shading techniques. Shade with soft strokes to create lighter tones, or put more pressure on your pencil and shade with heavy strokes to create darker tones. These contrasts in value (the relative lightness or darkness of a color or of black) are what give depth and form to your drawings.

Gradating with Pressure A gradation is a transition of tone from dark to light. To create a simple gradation using one pencil, begin with heavier pressure and gradually lighten it as you stroke back and forth. Avoid pressing hard enough to score or completely flatten the tooth of the paper.

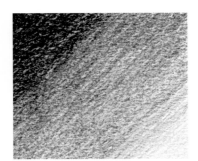

Gradating with Hardness Because different pencil hardnesses yield different values, you can create a gradation by using a series of pencils. Begin with soft, dark leads and switch to harder, grayer tones as you move away from the starting point.

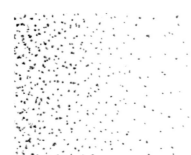

Stippling Apply small dots of graphite for a speckled texture. To prevent this technique from appearing too mechanical, subtly vary the dot sizes and distances from each other.

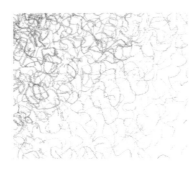

Scumbling This organic shading method involves scribbling loosely to build up general tone. Keep your pressure light and consistent as you move the pencil in random directions.

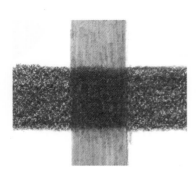

Burnishing It is difficult to achieve a very dark tone with just one graphite pencil, even when using a soft lead. To achieve a dark, flat tone, apply a heavy layer of soft lead followed by a layer of harder lead. The hard lead will push the softer graphite into the tooth of the paper, spreading it evenly. Shown at right is 4H over 4B lead.

This is an oval shape.

This has a three-dimensional, ball-like form.

APPLYING GRAPHITE WITH A BLENDER

Chamois Using a chamois is a great way to apply graphite to a large area. Wrap it around your finger and dip it in saved graphite shavings to create a dark tone, or use what may be already on the chamois to apply a lighter tone.

Stump Stumps are great not only for blending but also for applying graphite. Use an old stump to apply saved graphite shavings to both large and small areas. You can achieve a range of values depending on the amount of graphite on the stump.

Indenting To preserve fine white lines in a drawing, such as those used to suggest whiskers, some artists indent (or incise) the paper before applying tone. Use a stylus to "draw" your white lines; then stroke your pencil over the area and blend. The indentations will remain free of tone.

"Drawing" with an Eraser Use the corner of a block eraser or the end of a stick eraser to "draw" within areas of tone, resulting in light strokes. You can use this technique to recover lights and highlights after blending.

Hatching Hatching is considered one of the simplest forms of shading. Simply apply a series of parallel lines to represent darker tones and shadows. The closer together you place the lines, the darker the shading will appear.

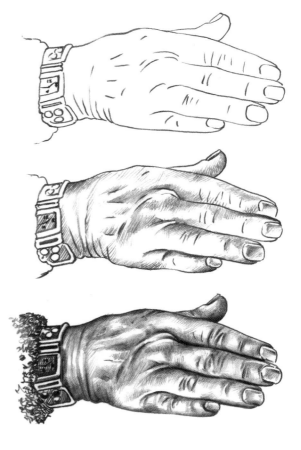

Crosshatching To crosshatch, place layers of parallel lines over each other at varying angles. This results in a "mesh" of tone that gives shaded areas a textured, intricate feel. For an added sense of depth, make the lines follow the curves of your object's surface.

As you shade, follow the angle of the object's surface, and blend to allow the texture to emerge.

ADULT HEADS

Understanding the basic rules of human proportions (meaning the comparative sizes and placement of parts to one another) is imperative for accurately drawing the human head. Understanding proper proportions will help you determine the correct size and placement of each facial feature, as well as how to modify them to fit the unique, individual characteristics of your subject.

Frontal View

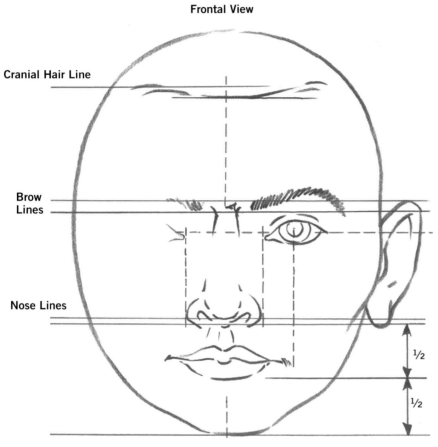

Cranial Hair Line

Brow Lines

Nose Lines

½

½

Draw a basic oval head shape, and divide it in half with a light, horizontal line. On an adult, the eyes fall on this line, usually about one "eye-width" apart. Draw another line dividing the head in half vertically to locate the position of the nose.

The bottom lip rests halfway between the nose and the chin.

Head Length

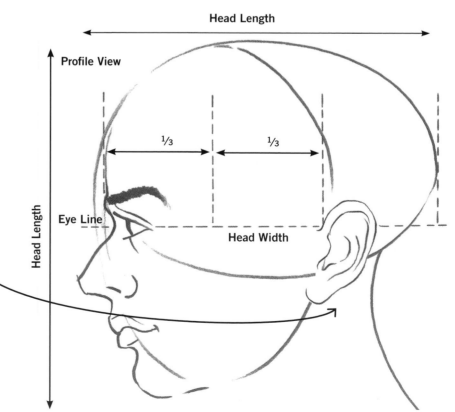

Profile View

⅓ ⅓

Head Length

Eye Line

Head Width

The horizontal length of the head, including the nose, is usually equal to the vertical length. Divide the cranial mass into thirds to help place the ear.

HEAD POSITIONS & ANGLES

The boxes shown here correlate with the head positions directly below them. Drawing boxes like these first will help you correctly position the head. The boxes also allow the major frontal and profile planes, or level surfaces, of the face to be discernible. Once you become comfortable with this process, practice drawing the heads shown on this page.

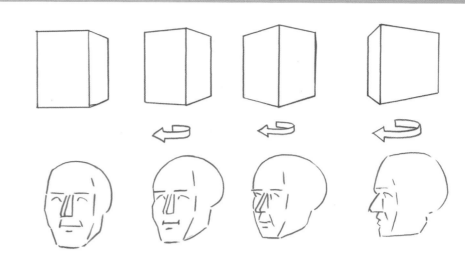

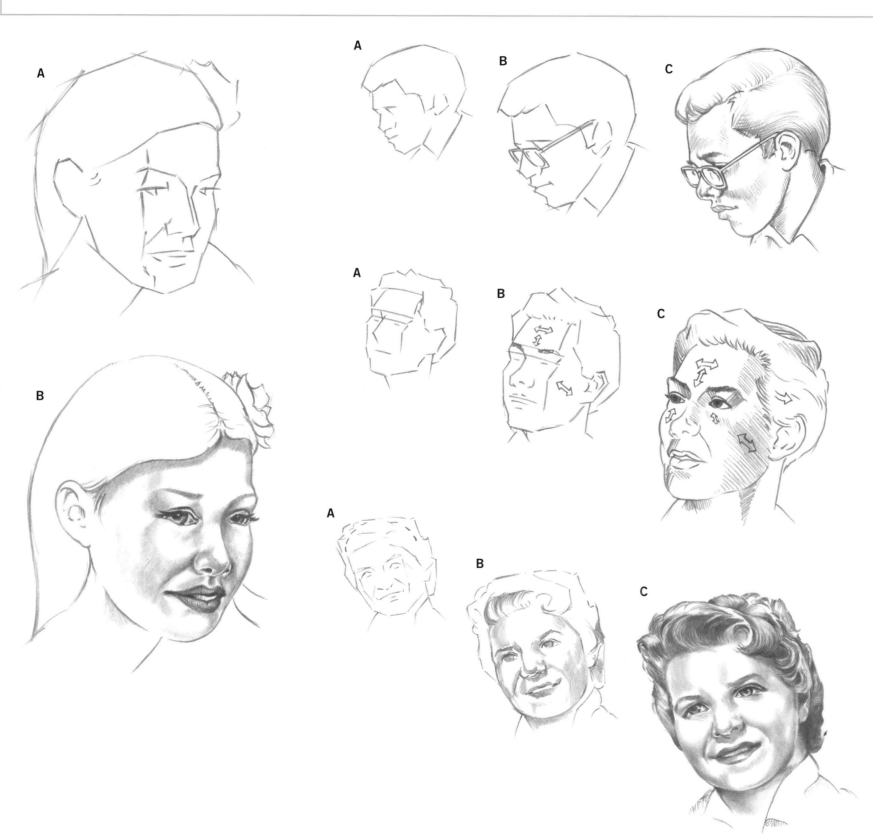

THE PROFILE

Beginning artists often study profile views first, as this angle tends to simplify the drawing process. For example, in a profile view, you don't have to worry about aligning symmetrical features. But the rules of proportion still apply when drawing more complex views of the head.

A

When shading the profile or any view of the face, it's important to recognize the different planes of the face, illustrated in this drawing.

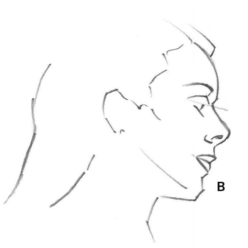

B

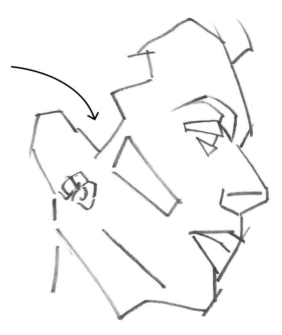

Planes of the Face

Use a sharp 2B pencil to fill in darker areas, such as wrinkles or creases. Use a paper stump to soften smoother features, such as cheeks.

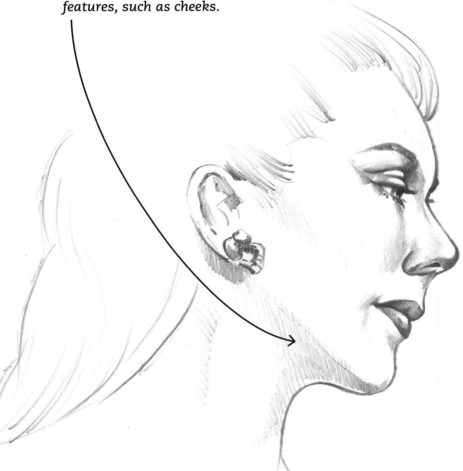

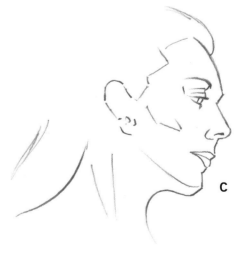

C

Although the nose is a prominent part of the profile, make certain it doesn't dominate the entire drawing. Take as much time drawing the other features as you would the nose.

A B C

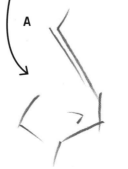
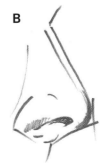
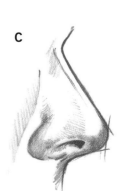

THE THREE-QUARTER VIEW

Although the three-quarter view may seem difficult, it can be drawn by following all of the techniques you've already learned.

Use the proper head proportions to lightly sketch the guidelines indicating where the main features will be located.

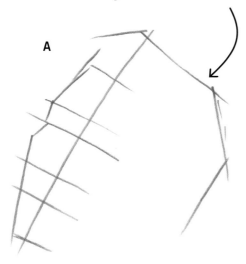

A

Sketch the eyes and mouth on the guidelines you've drawn.

C

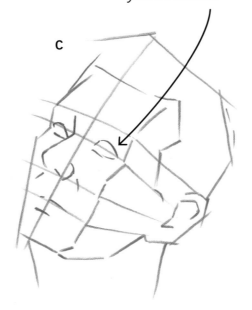

D

Smooth out your block-in lines, shading lightly with an HB pencil to bring out the face's three-dimensional form.

B

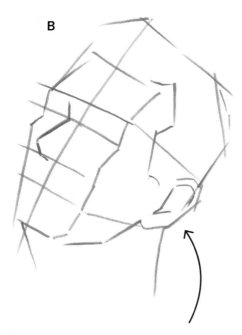

Begin blocking in the shape of the head; then add the hairline, and sketch the ear. Bring out the planes of the face (imagine a box), and position the nose correctly.

Fill in the creases and details with a sharp-pointed pencil; then use a kneaded eraser molded into an edge or point to pull out the highlights in the hair.

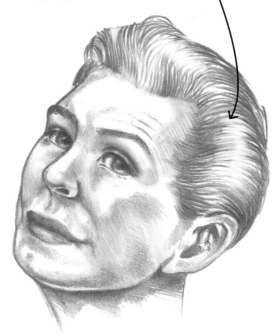

CHILD HEAD PROPORTIONS

The proportions of a child's head differ from those of an adult. Children generally have bigger foreheads; therefore the eyebrows—not the eyes—fall on the center horizontal division line. Also, the eyes of youngsters are usually larger and rounder than the eyes of adults.

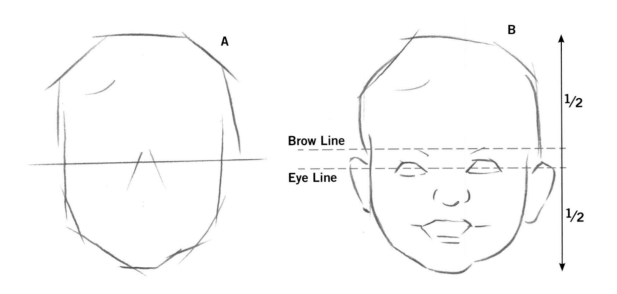

Brow Line

Eye Line

½

½

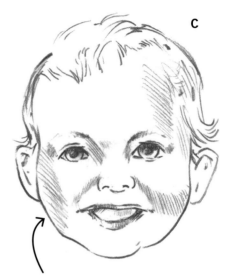

The younger the child, the smoother the skin and facial features. Keep your shading even and relatively light.

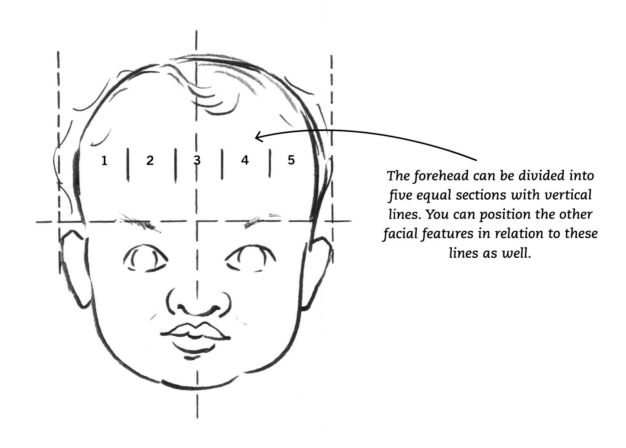

1 | 2 | 3 | 4 | 5

The forehead can be divided into five equal sections with vertical lines. You can position the other facial features in relation to these lines as well.

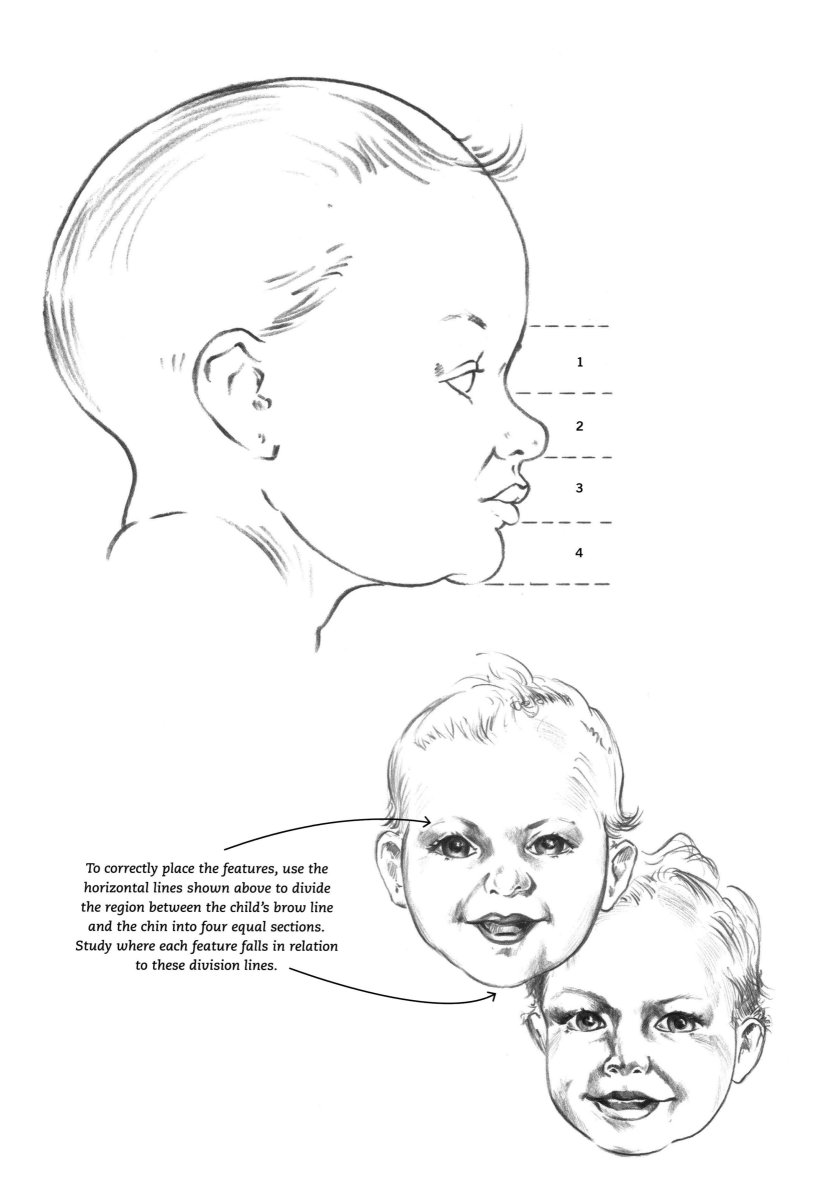

1

2

3

4

To correctly place the features, use the horizontal lines shown above to divide the region between the child's brow line and the chin into four equal sections. Study where each feature falls in relation to these division lines.

Practice drawing boys and girls of various ages in different head positions. Keep the shading simple and smooth in these drawings to capture each child's youthful qualities.

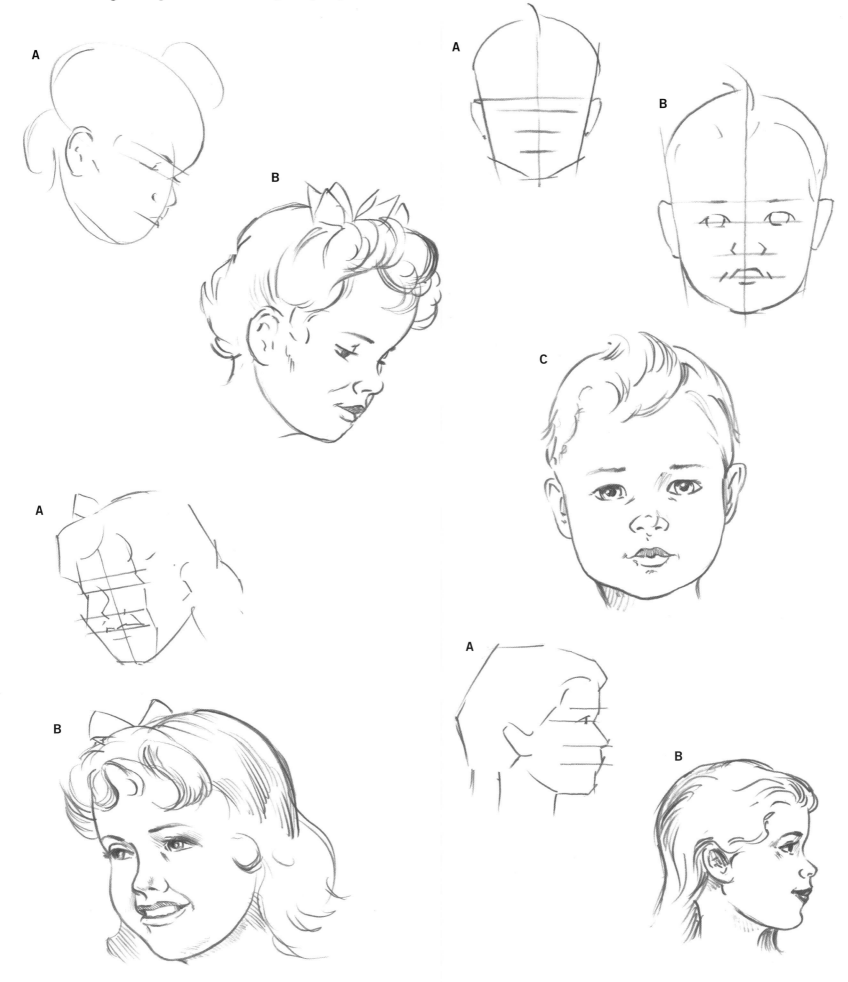

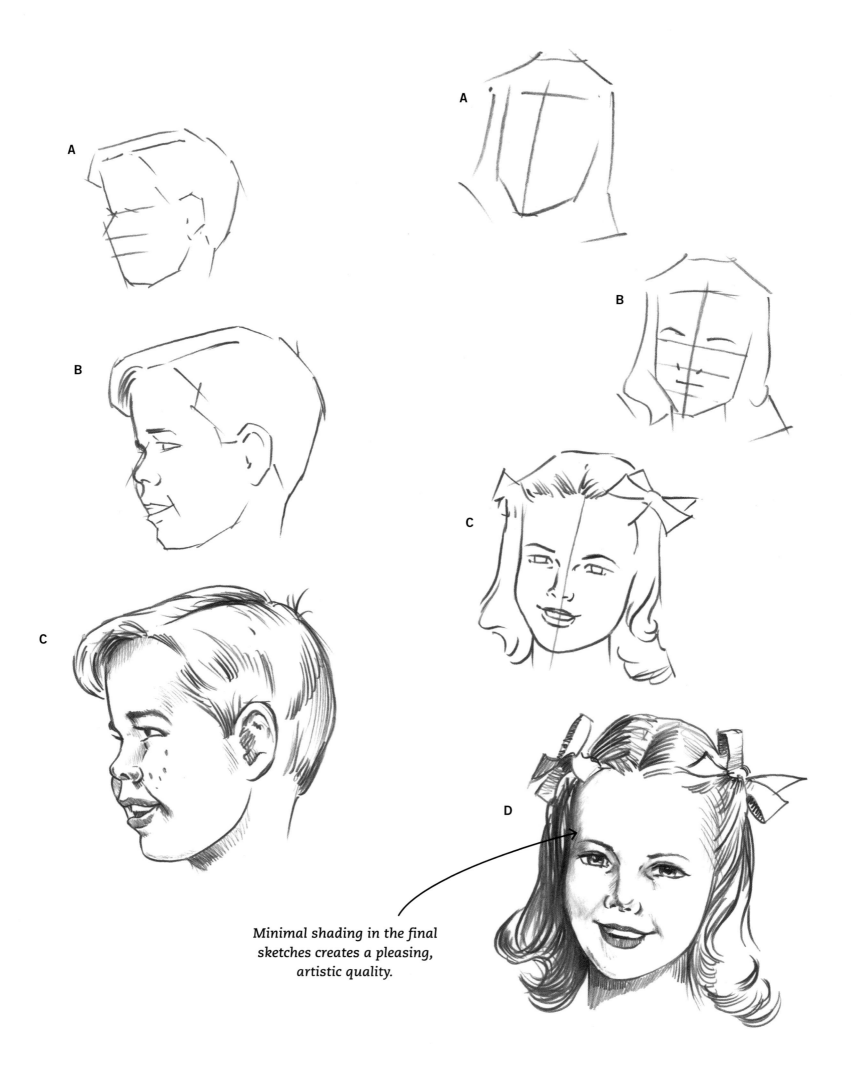

A

B

C

A

B

C

D

Minimal shading in the final sketches creates a pleasing, artistic quality.

FACIAL FEATURES

The eyes are the most important feature for achieving a true likeness. They also reveal the emotion of the person you are drawing. Learn to draw the facial features—eyes, eyebrows, noses, ears, and lips—separately before putting them together to draw a whole face.

EYES

Study and practice these diagrams showing how to block in frontal and profile views of the eyes, and notice that with the profile, you don't begin with the same shape as with the frontal view.

A

B
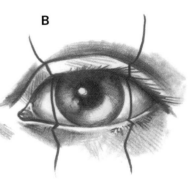

Outside Eye Contours (Front)

A
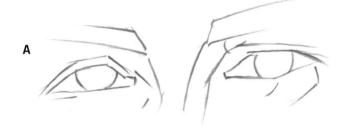

B
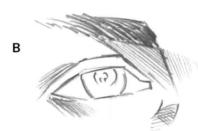
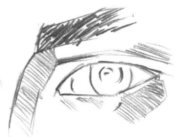

C
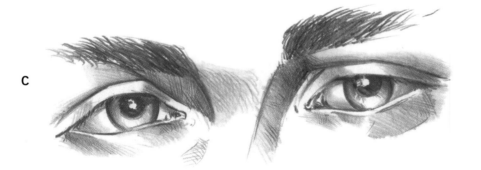

TIP

Even if the rest of the features are correct, if the eyes aren't drawn correctly, your drawing won't look like your subject. A person's eyes are rarely symmetrical. Look for the subtle differences in each eye to achieve a real likeness.

A
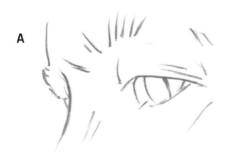

B
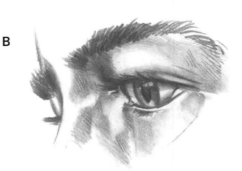

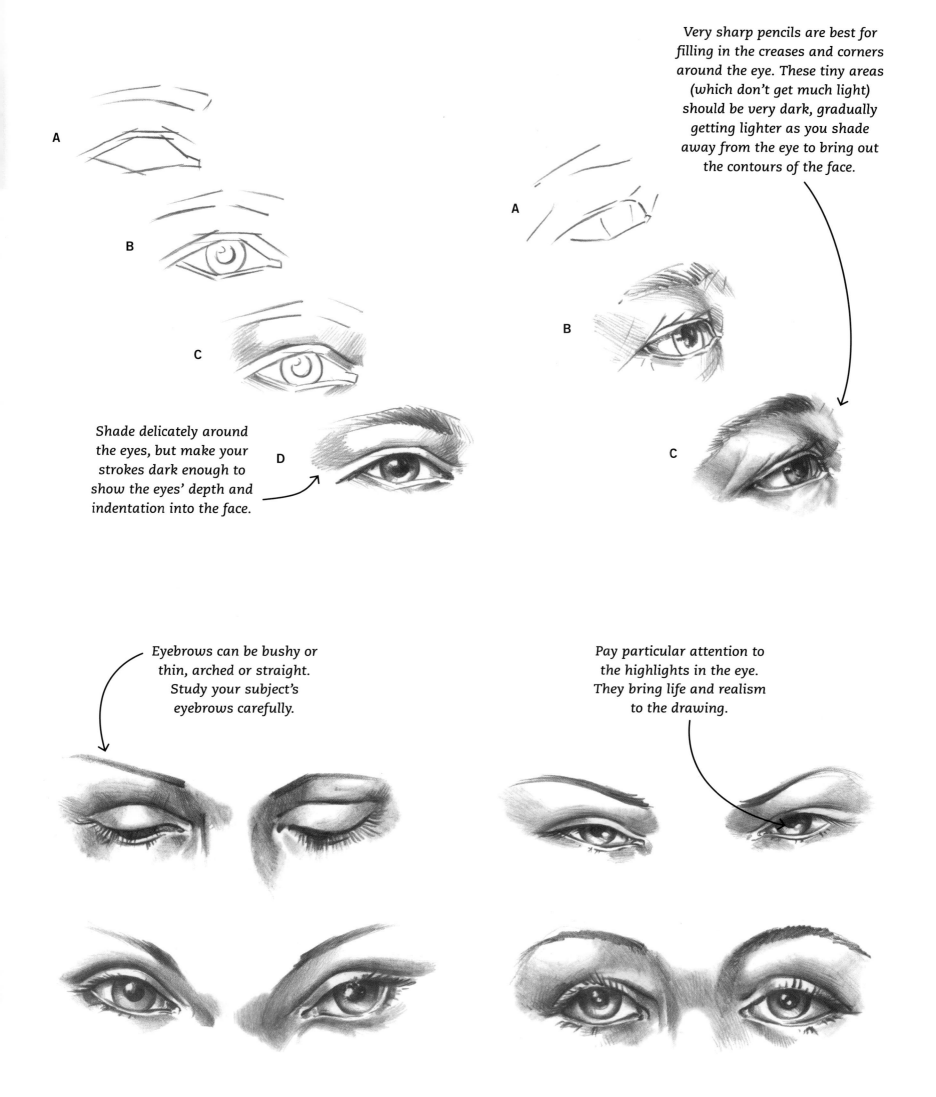

A

B

C

Shade delicately around the eyes, but make your strokes dark enough to show the eyes' depth and indentation into the face.

D

Very sharp pencils are best for filling in the creases and corners around the eye. These tiny areas (which don't get much light) should be very dark, gradually getting lighter as you shade away from the eye to bring out the contours of the face.

A

B

C

Eyebrows can be bushy or thin, arched or straight. Study your subject's eyebrows carefully.

Pay particular attention to the highlights in the eye. They bring life and realism to the drawing.

NOSES

Noses can be easily developed from simple straight lines. The first step is to sketch the overall shape as illustrated by the sketches below. Then smooth out the corners into subtle curves in accordance with the shape of the nose. A three-quarter view can also be drawn with this method. Once you have a good preliminary drawing, begin shading to create form.

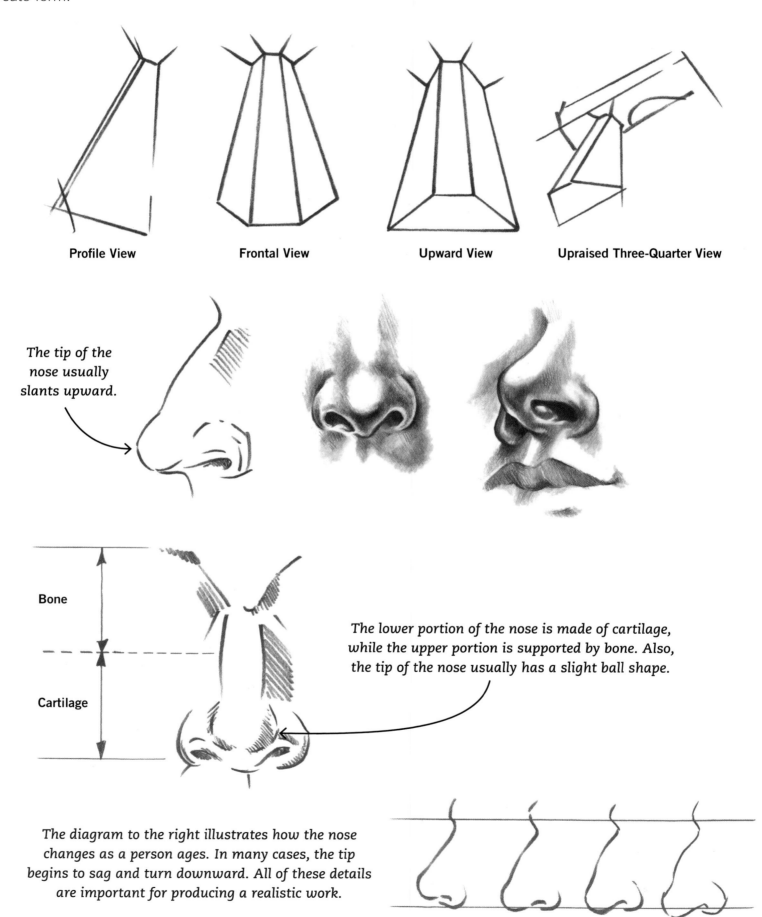

Profile View **Frontal View** **Upward View** **Upraised Three-Quarter View**

The tip of the nose usually slants upward.

Bone

Cartilage

The lower portion of the nose is made of cartilage, while the upper portion is supported by bone. Also, the tip of the nose usually has a slight ball shape.

The diagram to the right illustrates how the nose changes as a person ages. In many cases, the tip begins to sag and turn downward. All of these details are important for producing a realistic work.

Process of an Aging Nose

EARS

Ears usually connect to the head at a slight angle. To draw an ear, first sketch the general shape, and divide it into thirds. Sketch the "ridges" of the ear with light lines, studying where they fall in relation to the division lines. These ridges indicate where to bring out the grooves in the ear; you should shade heavier inside them.

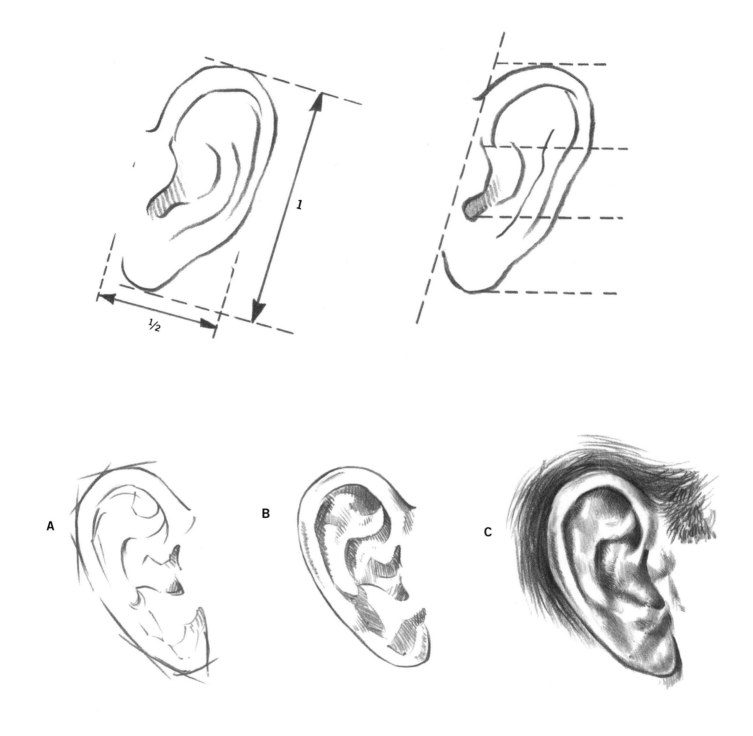

LIPS

Lips can be very easy to draw if you study their form closely. For example, notice that the top lip often protrudes slightly over the bottom one. You should also familiarize yourself with the various planes of the lips to shade them well.

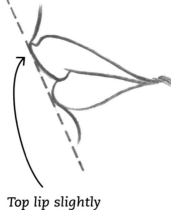

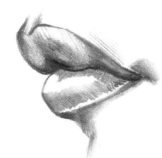

Top lip slightly protrudes.

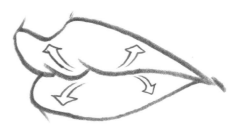

Shade in the direction of the planes of the lips.

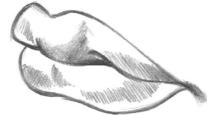

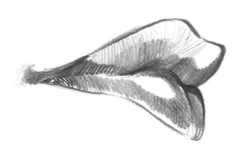

A

Block in the overall mouth shape with preliminary guidelines.

B

Begin shading, paying particular attention to where the highlights are located.

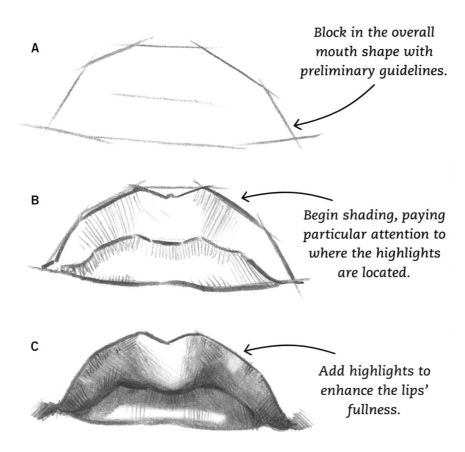

C

Add highlights to enhance the lips' fullness.

TIP

When drawing lips, keep the shading light unless you want them to appear as though they're covered with lipstick.

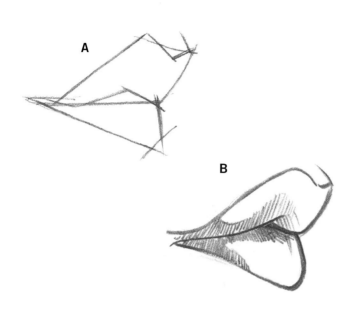

A

B

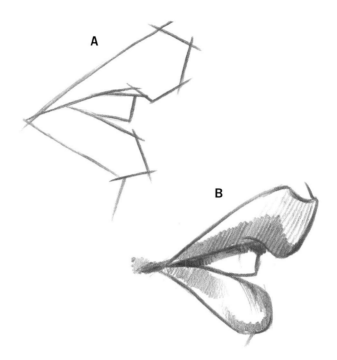

A

B

Divide the upper lip into three parts and the lower lip into two parts. These light division lines will help you draw the top and bottom lips in proportion with each other.

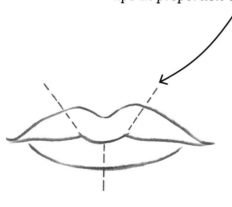

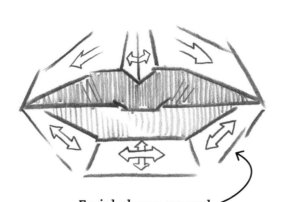

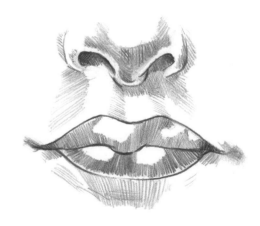

Facial planes around the mouth

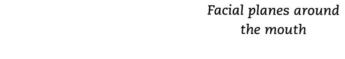

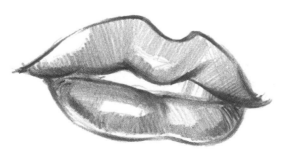

Determine how much detail you'd like to add. For instance, these examples don't show any clearly defined teeth, but how you handle this depends on personal preference.

THE SMILE

Facial expressions will add life to your artistic work because your drawings will seem more realistic. One of the most basic ways to create expression is with a smile. When a person smiles, the rest of the facial features are affected. For example, the bottom eyelids move slightly upward, making the eyes appear smaller.

A

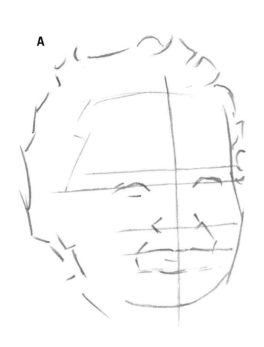

B

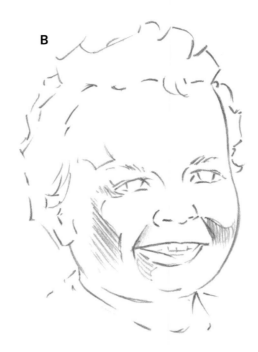

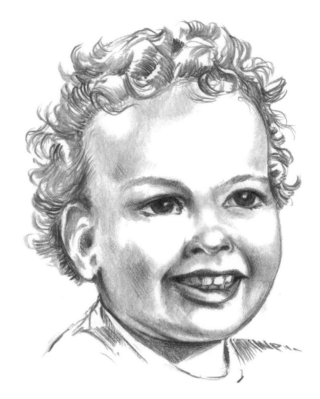

Smiling also causes creases around the mouth, produces more highlights on the cheek area, and the cheeks become fuller and rounder. The lips, on the other hand, require fewer highlights because the smile causes them to flatten out somewhat.

A

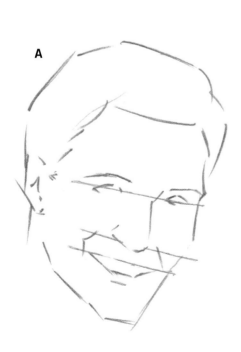

B

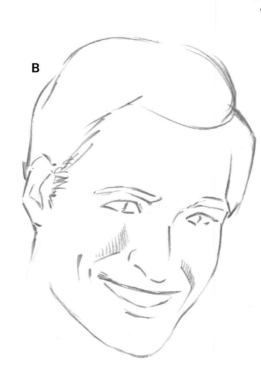

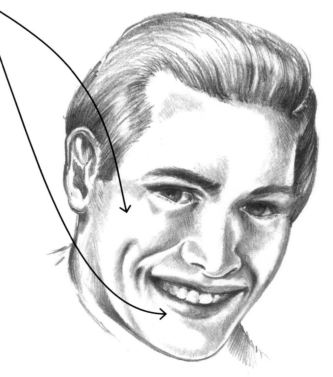

THE FACE

Once you've mastered drawing separate facial features, combine them to build the entire face.
Use the head proportions you've already learned to correctly place the features.

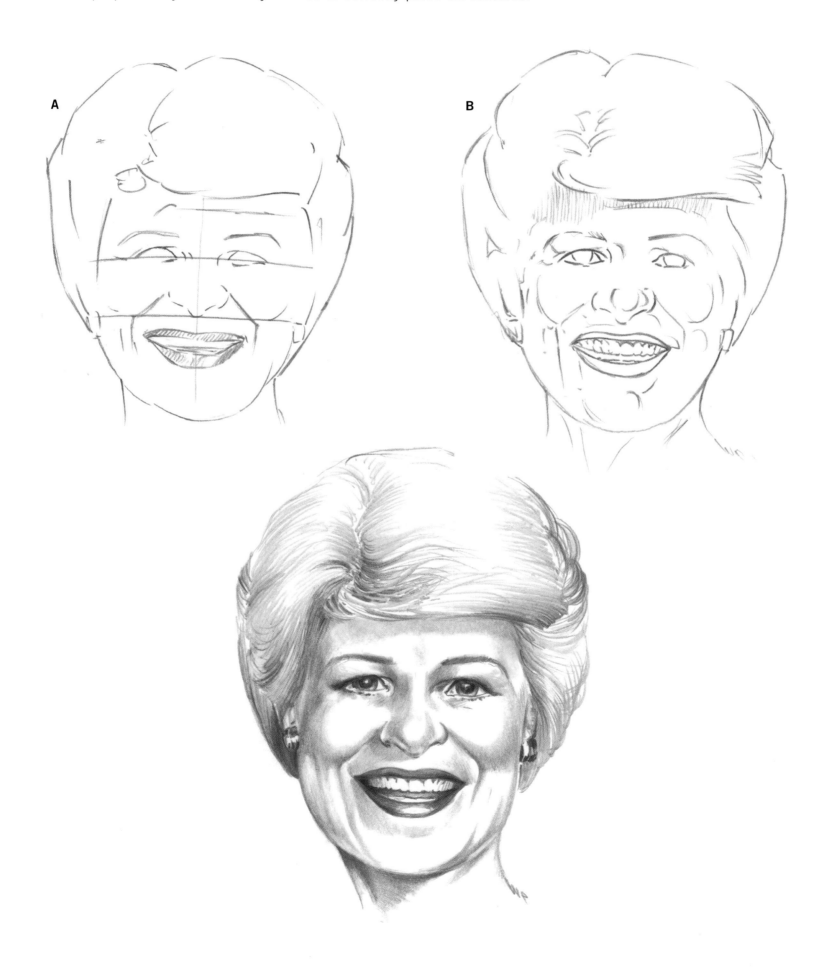

PORTRAITS

A human face has contours just like a landscape, an apple, or any other subject. The difference is that the contours of the face change slightly from individual to individual. The "trick" to portraiture is observing these differences and duplicating them in your drawings.

Once you've drawn the basic head shape, lightly indicate where any wrinkles will be. Some of the minor lines can be suggested through shading.

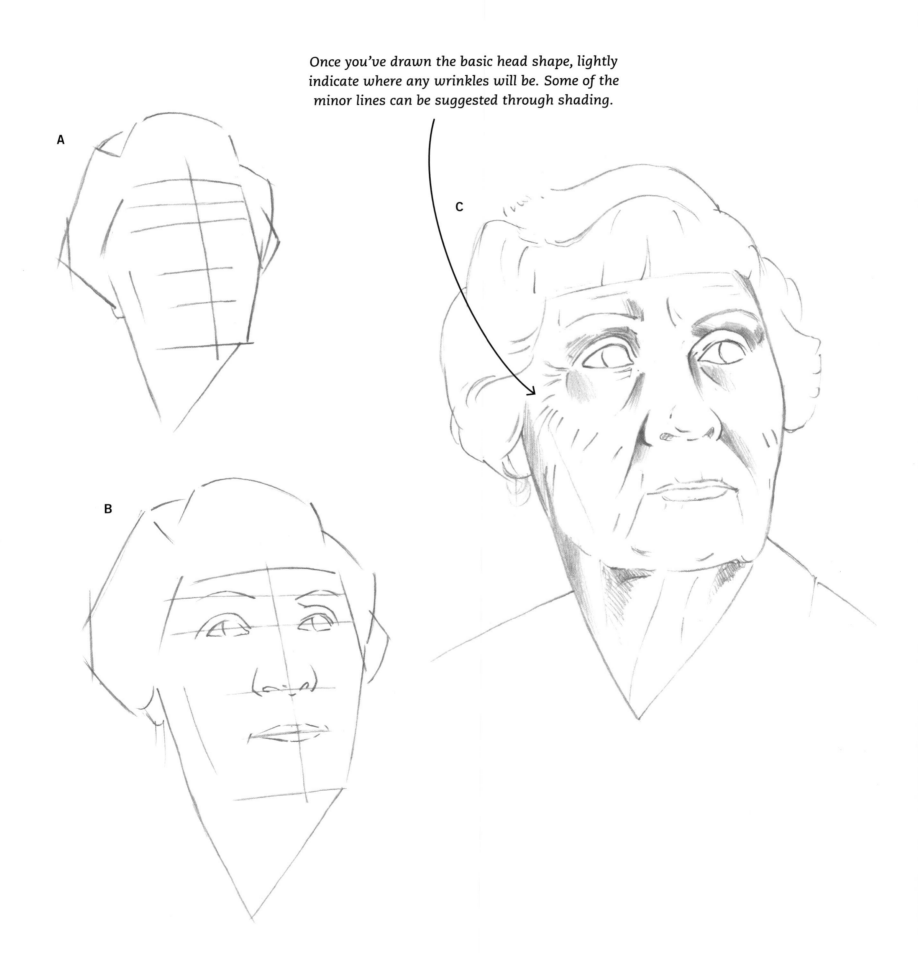

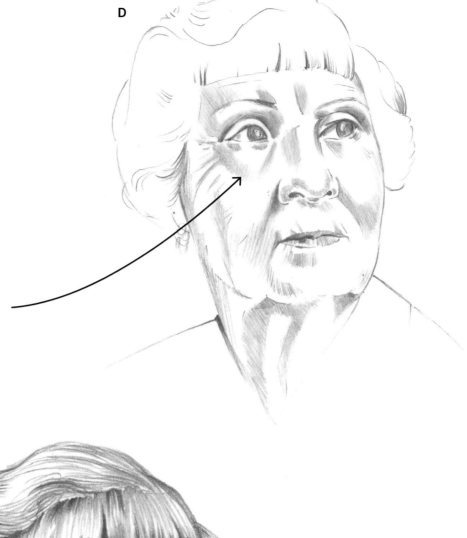

D

Shade delicately with a sharpened 2B pencil. A sharp, dark lead is best for drawing tiny details, such as creases in the lips, fine hair strands, and the corners of the eyes.

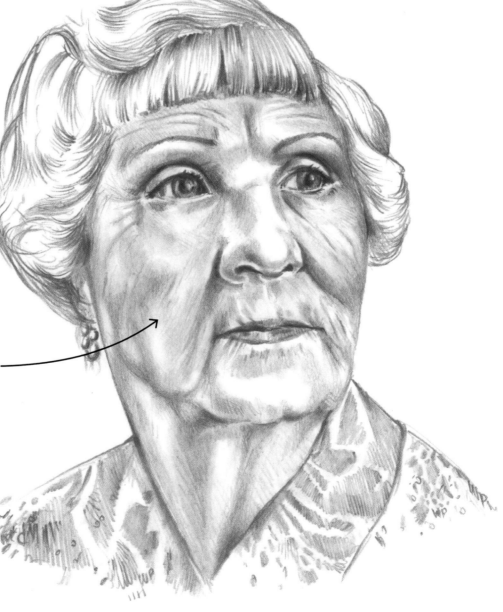

Your shading should help the features "emerge" from the face. Again, notice the areas where there is no shading and how these areas seem to come toward you.

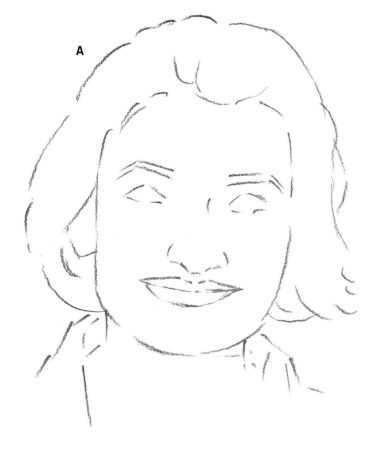

A

Start with a sharp HB charcoal pencil and very lightly sketch the general shapes. Charcoal allows very subtle value changes for this drawing.

B

Next begin to refine the features, adding the pupil and iris in each eye, plus dimples and smile lines. Then begin adding a few shadows.

C

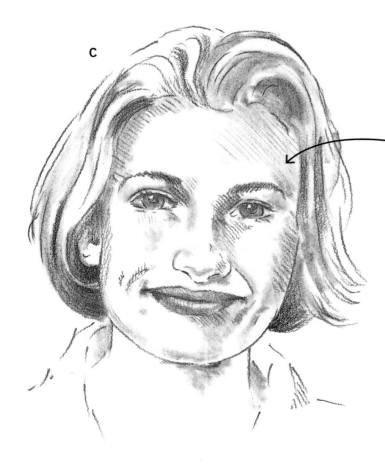

As you develop the forms with shading, use the side of an HB charcoal pencil and follow the direction of the facial planes. Shape a kneaded eraser to a point to lift out the eye highlights, and use a soft willow charcoal stick for the dark masses of hair.

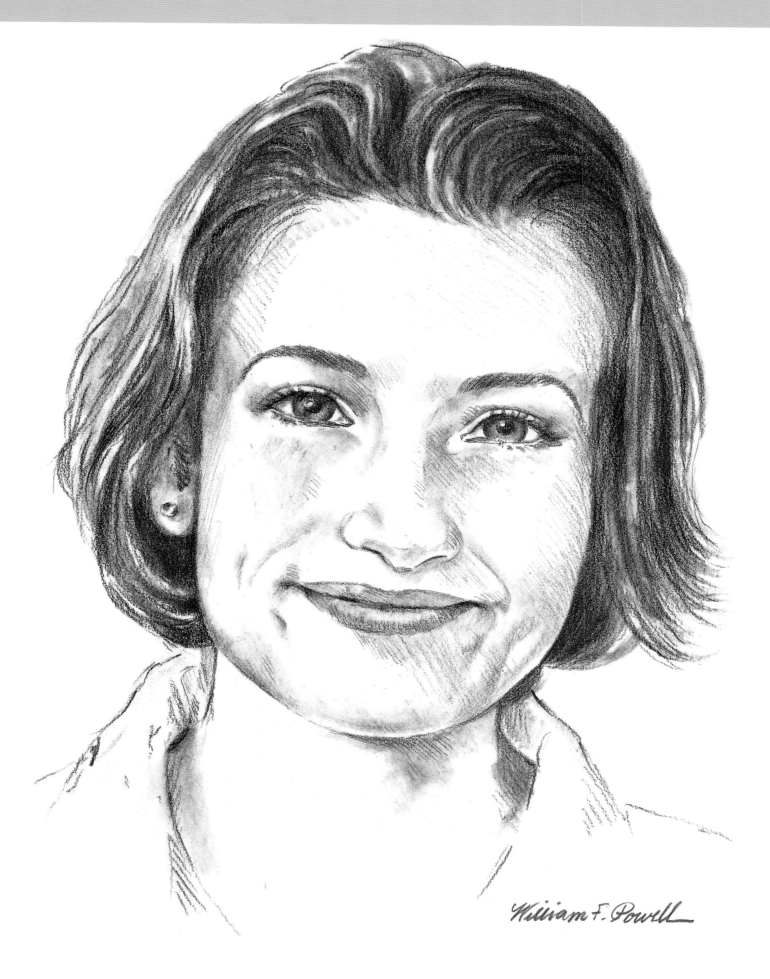

William F. Powell

Continue building up the shading with the charcoal pencil. For gradual blends and soft gradations of value, rub the area gently with your finger. (Don't use a brush or cloth to remove the excess charcoal dust; it will smear the drawing.) When finished, take the drawing outside, turn it over, and gently tap the back side to release any loose charcoal dust.

BODY PROPORTIONS

Just as there are proportion rules for drawing the head, guidelines exist for drawing the human body. You can use average or artistic measurements. The diagrams on this page effectively illustrate the differences between these types of proportions. Study them, and make many practice sketches.

Realistically, most adult bodies are about 7 ½ heads tall (average), but we usually draw them 8 heads tall (artistic) because a figure drawn only 7 ½ heads tall appears short and squatty.

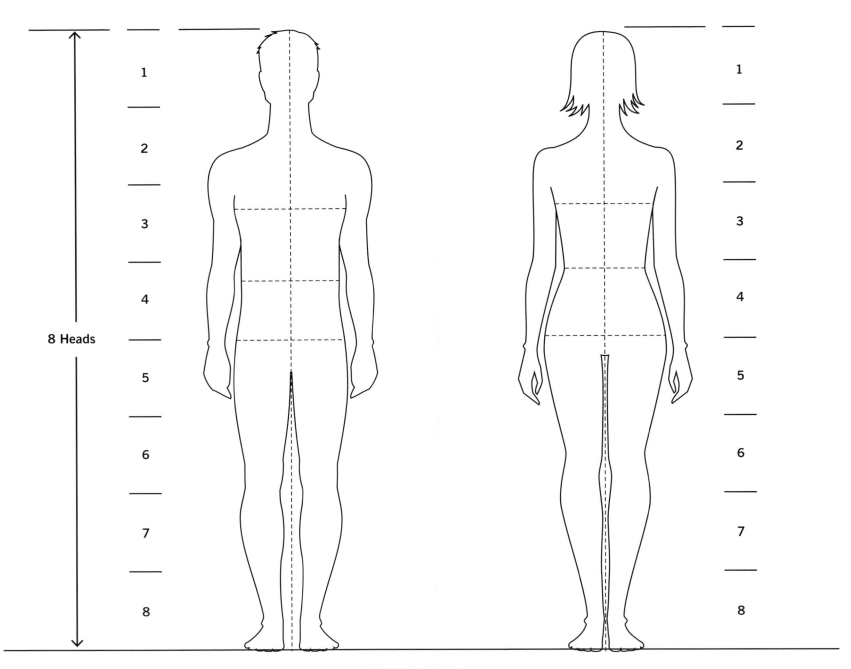

8 Heads

1
2
3
4
5
6
7
8

Artistic Proportions

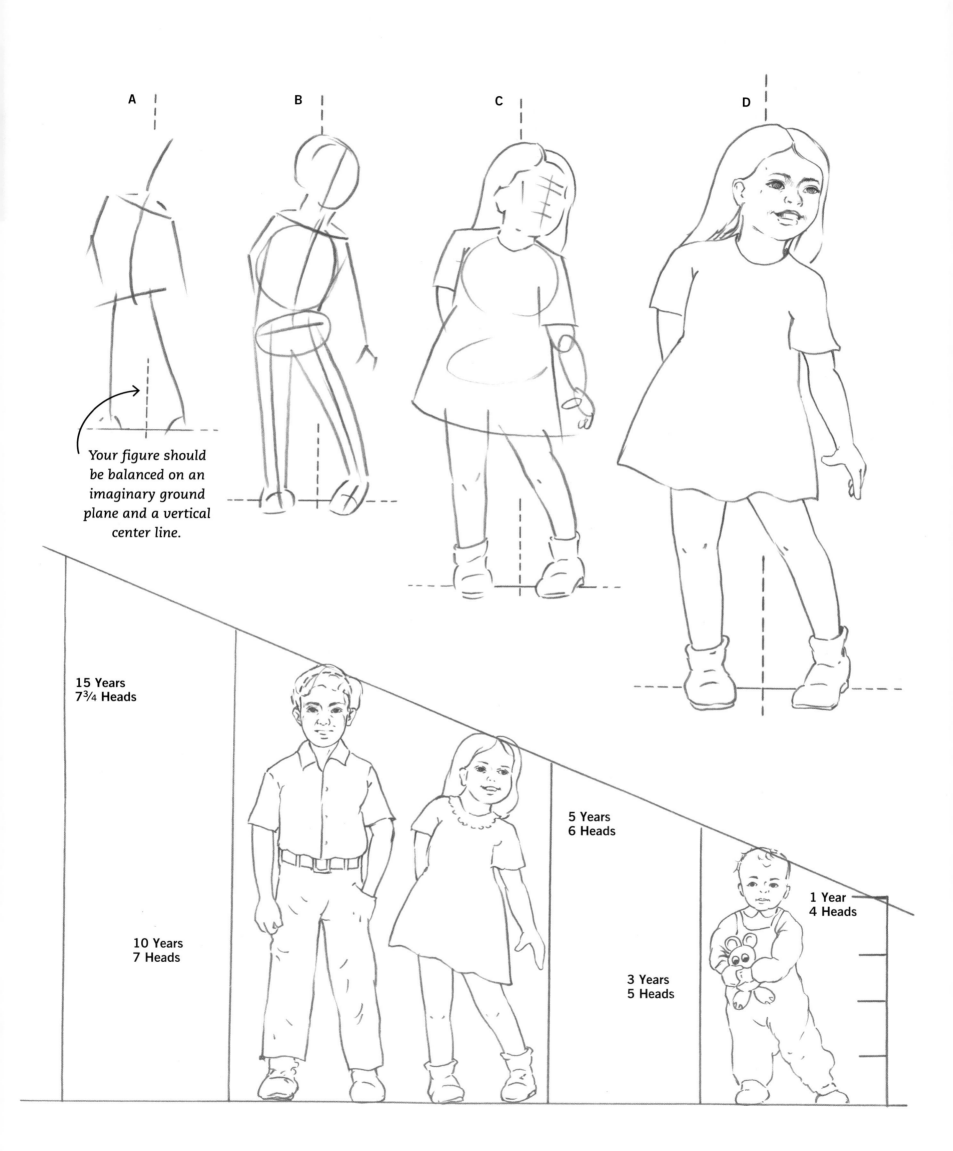

A

B

C

D

Your figure should be balanced on an imaginary ground plane and a vertical center line.

15 Years
7¾ Heads

10 Years
7 Heads

5 Years
6 Heads

3 Years
5 Heads

1 Year
4 Heads

HANDS & FEET

Hands and feet are very expressive parts of the body and are also an artistic challenge. Once you understand the basic structure of the hands and feet, you can simplify the complex shapes into geometric planes. These planes are also the foundation for shading, as they act as a guide to help you properly place highlights and shadows.

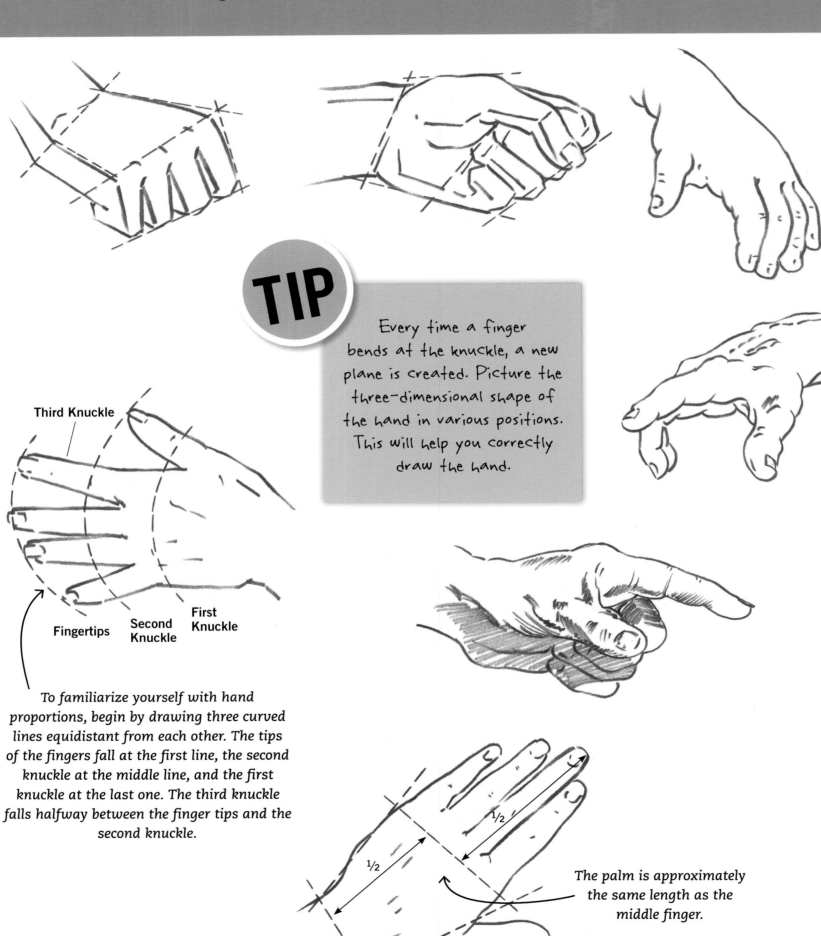

TIP

Every time a finger bends at the knuckle, a new plane is created. Picture the three-dimensional shape of the hand in various positions. This will help you correctly draw the hand.

Third Knuckle

Fingertips Second Knuckle First Knuckle

To familiarize yourself with hand proportions, begin by drawing three curved lines equidistant from each other. The tips of the fingers fall at the first line, the second knuckle at the middle line, and the first knuckle at the last one. The third knuckle falls halfway between the finger tips and the second knuckle.

½ ½

The palm is approximately the same length as the middle finger.

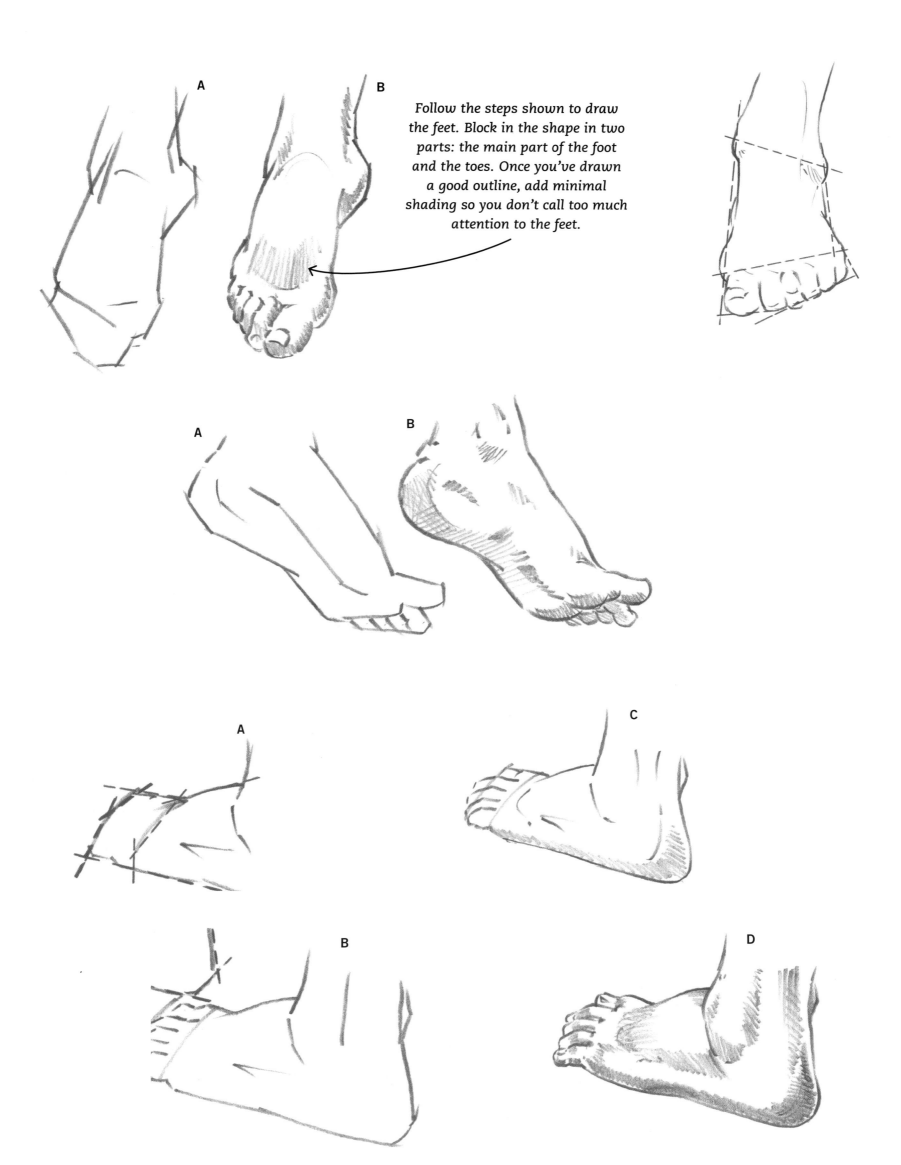

Follow the steps shown to draw the feet. Block in the shape in two parts: the main part of the foot and the toes. Once you've drawn a good outline, add minimal shading so you don't call too much attention to the feet.

MOVEMENT & BALANCE

Another way to make drawings more realistic is to draw the figures in action. Because people hardly ever sit or stand still, your figure drawings of them shouldn't either. You can begin by using simple sketch lines to lay out the dominant action of the figure.

Clothing helps convey the appearance of a twisting body. Use what you've learned about shading, keeping in mind that folds on a twisting body will be tighter than on a still pose.

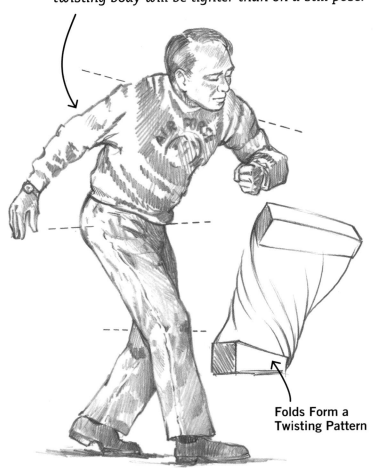

Folds Form a Twisting Pattern

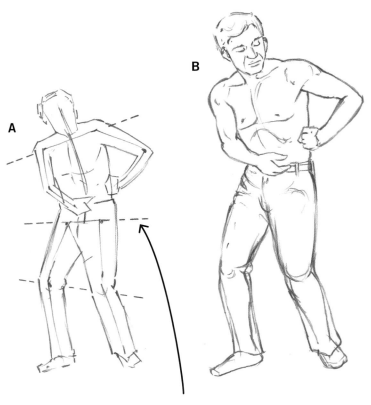

To accurately position the active body, sketch some guidelines to indicate the angles of the shoulders, hips, and knees, as shown in the examples.

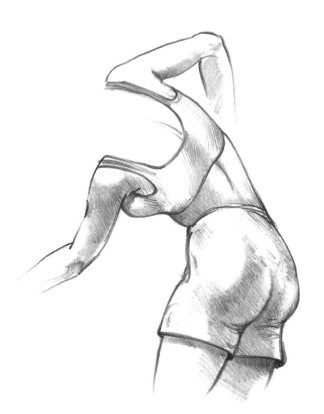

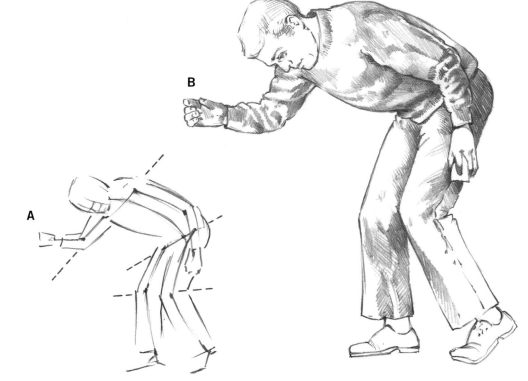

FORESHORTENING

Foreshortening allows you to create the illusion of an object coming toward you in space. Similarly, body proportions are somewhat skewed, or shortened, in a drawing that includes foreshortened subjects.

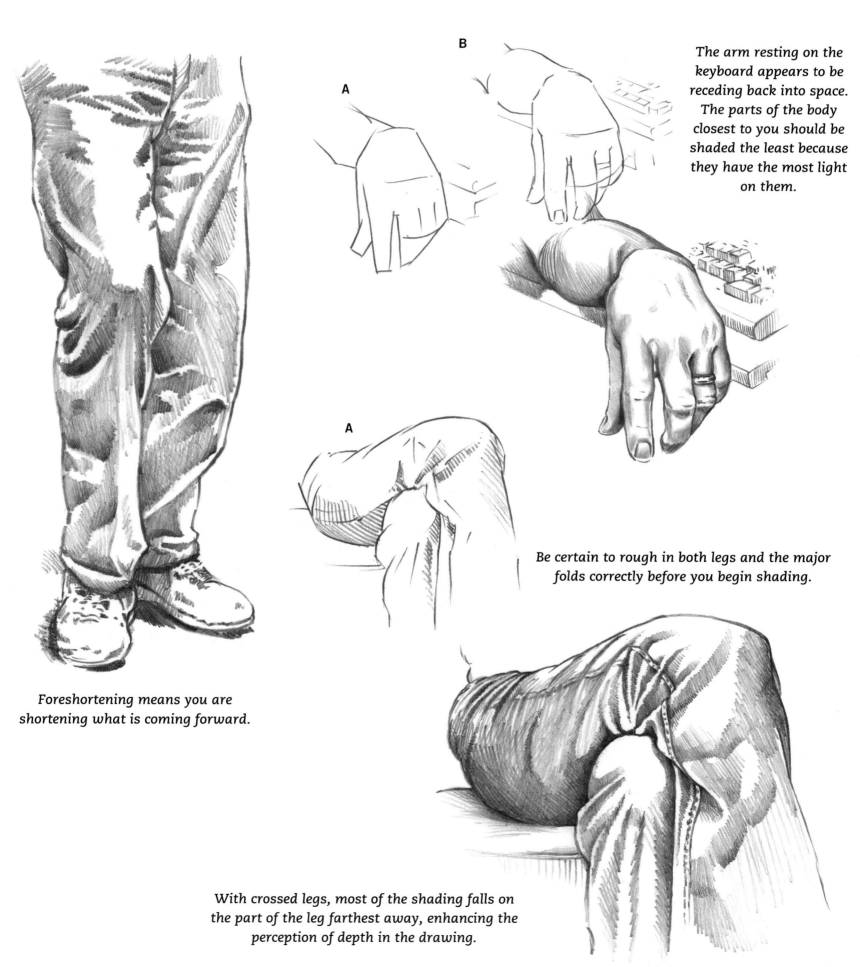

B

A

The arm resting on the keyboard appears to be receding back into space. The parts of the body closest to you should be shaded the least because they have the most light on them.

A

Be certain to rough in both legs and the major folds correctly before you begin shading.

Foreshortening means you are shortening what is coming forward.

With crossed legs, most of the shading falls on the part of the leg farthest away, enhancing the perception of depth in the drawing.

FIGURES IN ACTION

When drawing these figures in action, it's important to incorporate all of the drawing concepts explained in this book, including head and body proportions, center of balance, rendering hands and feet, clothing folds, and action poses.

Before drawing this ballerina, lightly sketch the center line of balance, as well as the action line representing the shape of her spine. Start out with straight lines to lay out her body in correct proportion, eventually smoothing out the lines with her body contours.

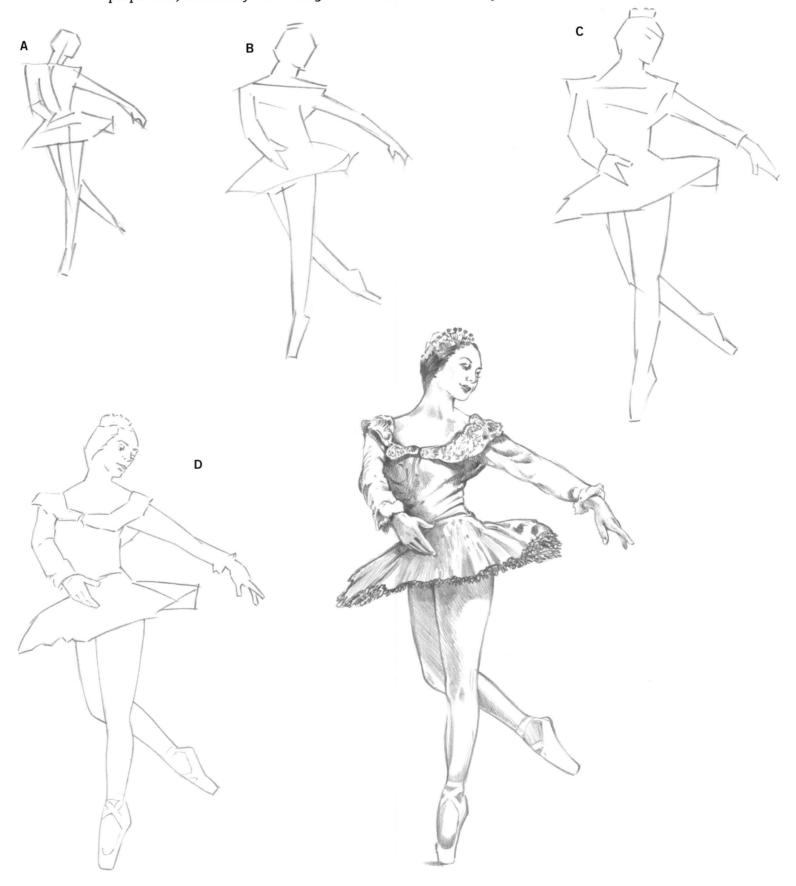

A

B

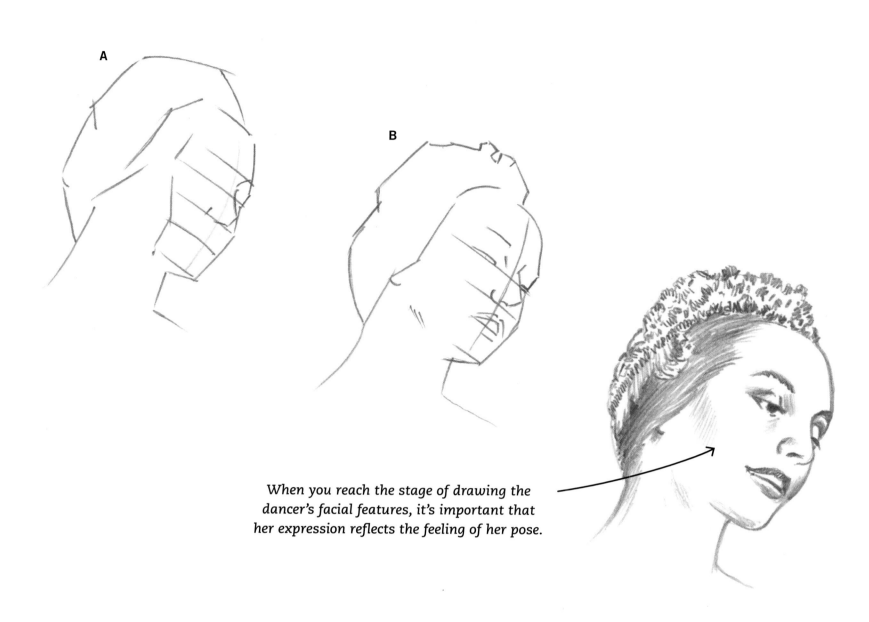

When you reach the stage of drawing the dancer's facial features, it's important that her expression reflects the feeling of her pose.

The position of this subject's hands also enhances her serene, graceful mood. Just as the ballerina appears delicate, so should the shading you apply on both her skin and costume. In other words, keep your shading minimal.

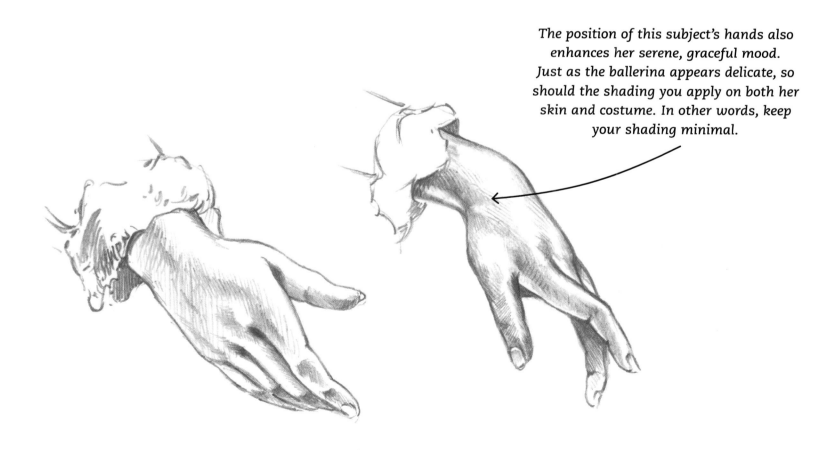

Notice that the line of action can be the same for two figures in different poses.

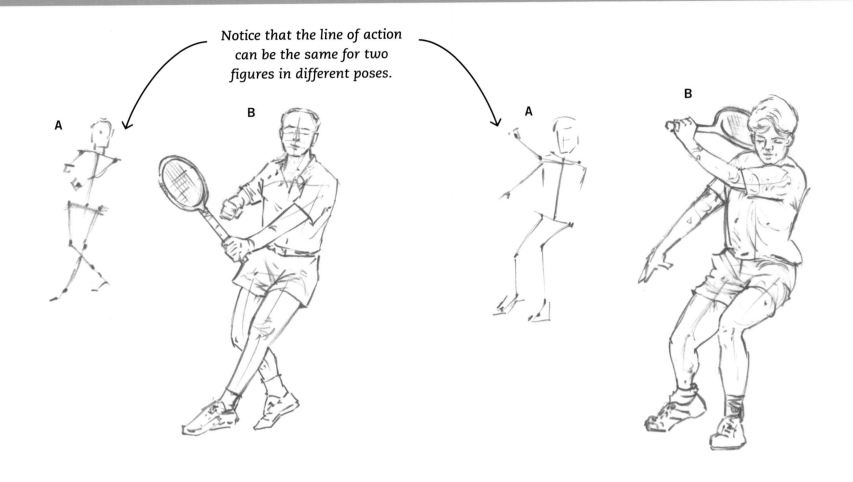

Once you've blocked in one figure, use it as a reference for blocking in the other one.

You want the figures to appear as part of the same drawing, and not like two people drawn separately and then placed together. Develop the shading for both figures at the same time.

Partial figures, such as this conductor, are another challenge. Pay particular attention to the angles of the arms, shoulders, and head—they determine the pose and mood of the person.

A

B

C

B

A

Angles will play a fundamental role in effectively rendering these figures. Use your knowledge of proportions extensively to capture the body movements.

Drawing figures playing sports is a great way to practice all of the techniques you've learned. It's especially important to sketch the line of action in such dramatic poses because the body often stretches, bends, and twists during these activities.

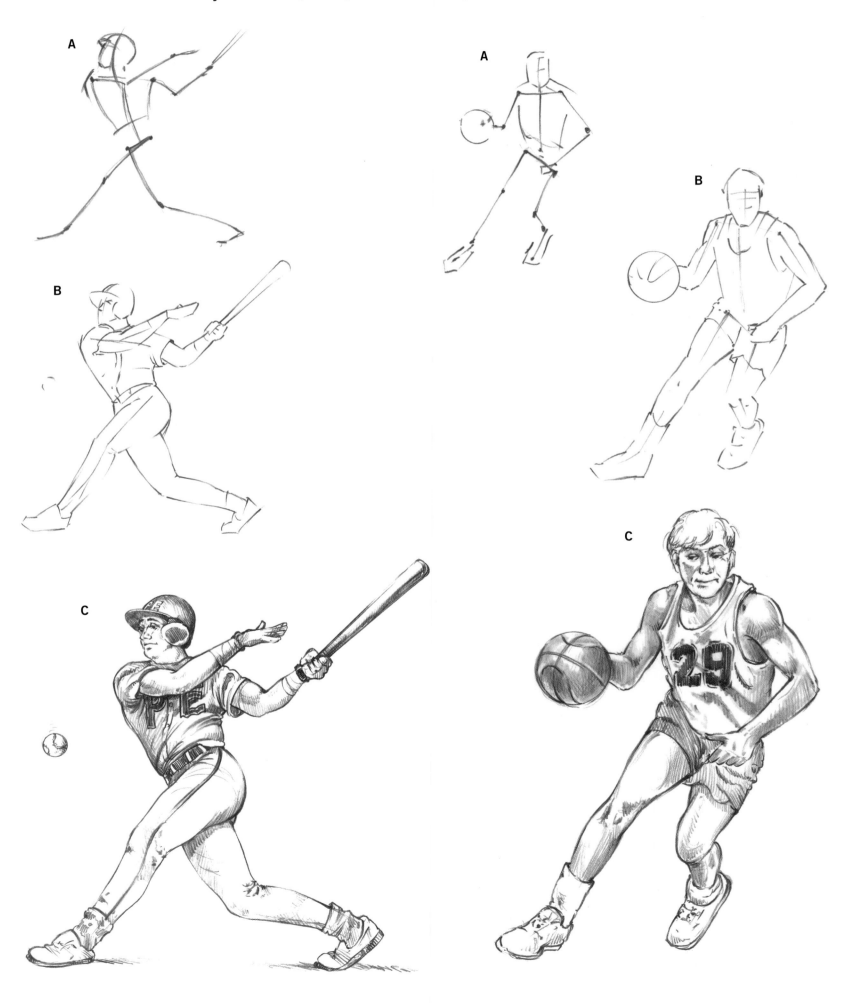

TIP

People playing sports often display expressions that contort their facial features, such as looks of grimace, shock, joy, or pain.

A

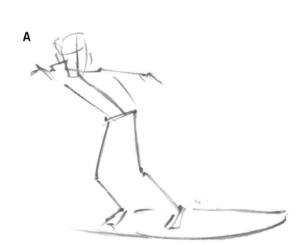

B

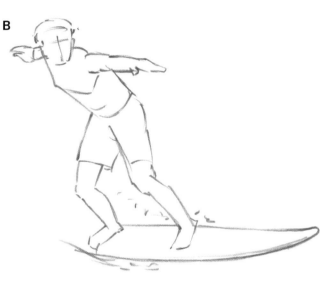

C

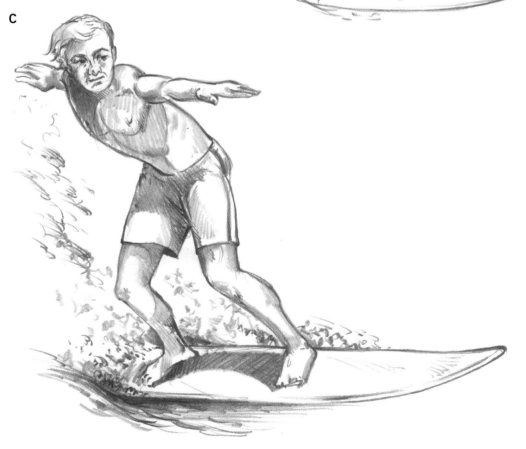

The same principles of drawing adults in action can be applied to drawing children. But remember, children's arms and legs are usually pudgier than those of an adult, and the proportions of children's bodies are different.

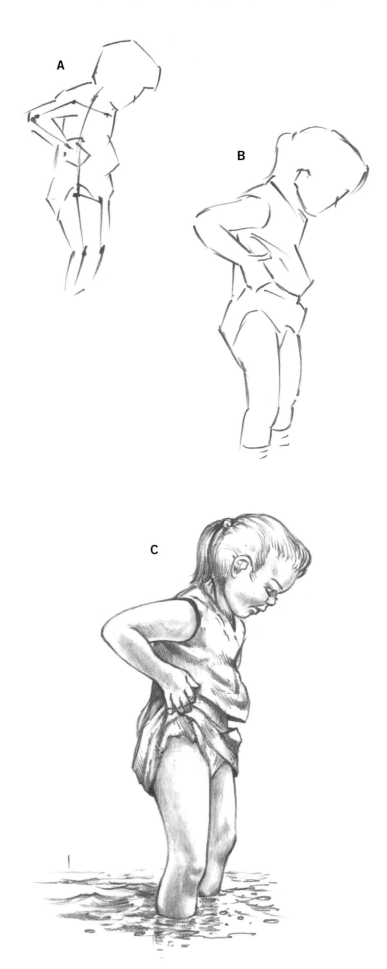

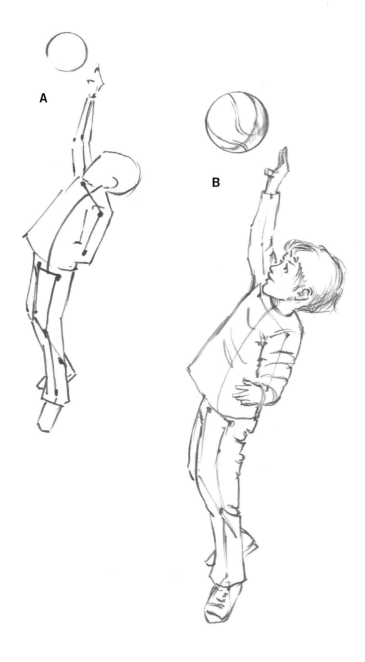

TIP

Recognize how the line of action differs from the boy jumping for the ball and the girl gathering flowers. Also, adding a ground, field, or river also enhances your work by providing a nice background for your subject.

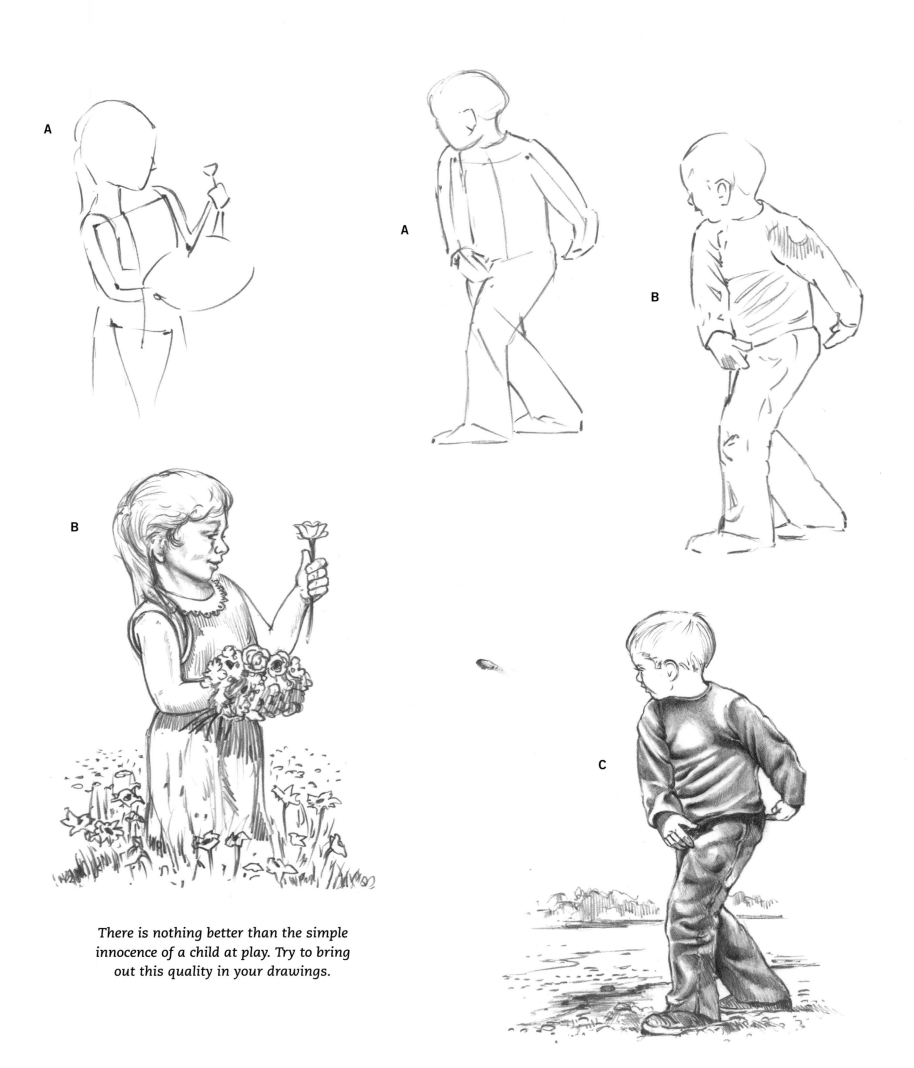

A

A

B

B

*There is nothing better than the simple
innocence of a child at play. Try to bring
out this quality in your drawings.*

C

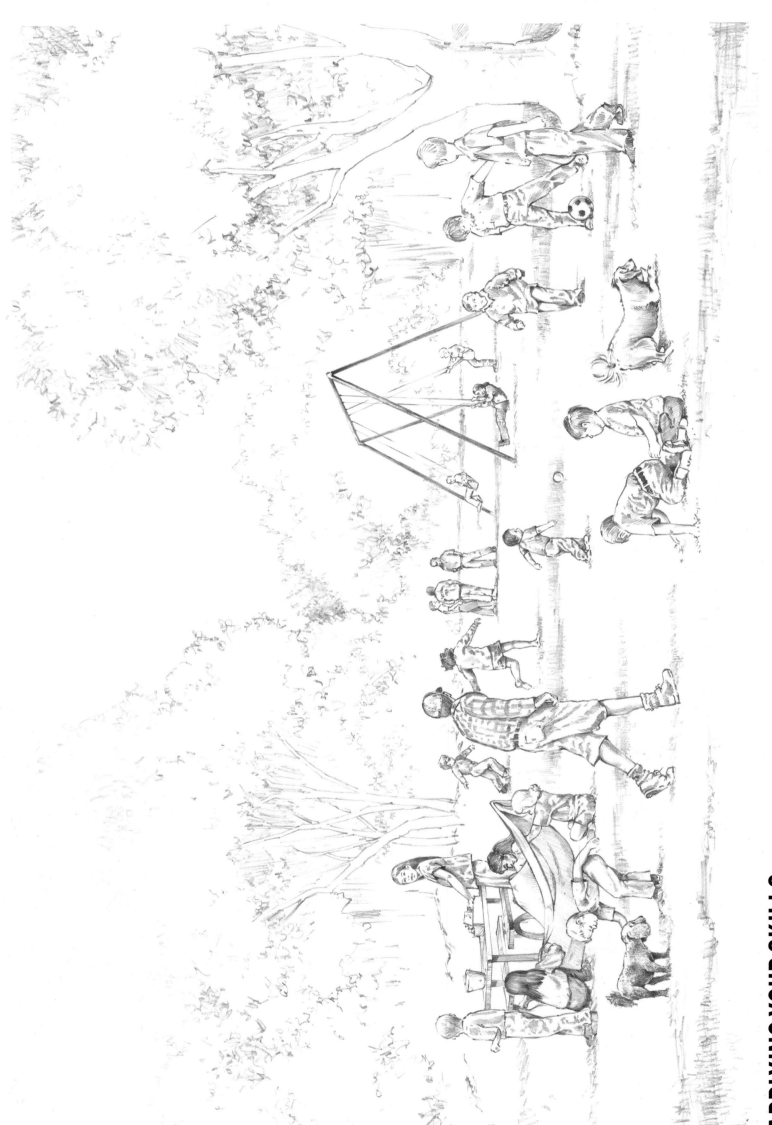

APPLYING YOUR SKILLS

Now that you've mastered all of the techniques in this book, you can incorporate them into one finished work. As you can see, this drawing demonstrates principles of perspective, line of action, and center of balance. It also illustrates successful renderings of figures bending and twisting, sitting, and moving in a variety of action poses. It's important that you attempt to draw a challenging work like this to improve your artistic skills. On location, record your subjects with quick simple lines, creating a reference for a tighter, more polished work back at home. Remember, success requires patience and a lot of practice.